THERAPY CHICKENS

LET THE WISDOM OF THE FLOCK
BRING YOU JOY

Tedra Hamel

wellfleet
press

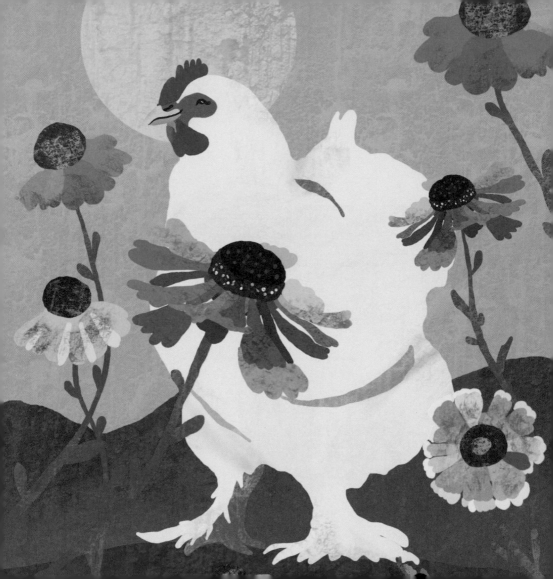

CONTENTS

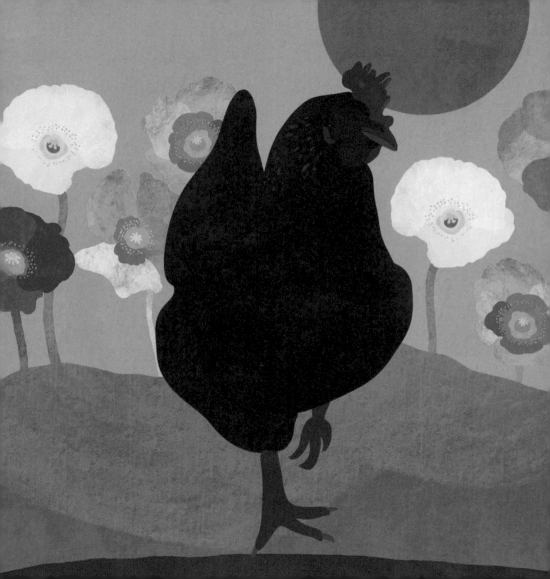

INTRODUCTION

I am sitting at the bedside of a very sick seven-year-old patient, comforting her father, who is on the verge of tears. Her condition has stabilized since earlier in the day, and you can see the grief and relief written plainly on his face. I let him know that his daughter is a fighter and that his presence is making her strong. He hangs his head in his hands. I place a page of chicken-themed stickers on the bed for his daughter when she wakes.

As I leave the room, I feel my heart being pulled in a million directions. This children's hospital is filled with hundreds of patients just like her. And at the county hospital where I will work tomorrow, there are hundreds more. Biking home in the wind and rain, I pass dozens of people without indoor housing in a city filled with unoccupied rooms. I try to open my heart to them too, yet I cannot deny that all I want to do is get back to my warm, cozy house. I glide into my driveway and dismount my bike. I take off my helmet, feeling the

gravity of the world's issues weighing heavily on me. I park my bike in the garage, wipe the rain and mud off my face, and immediately head to the chicken coop to lie down among my chickens for a few minutes.

At the time of writing this book, I am a nursing student in Seattle, Washington. I am also a chicken keeper, a self-taught artist, a millennial, a daughter, a sister, and a friend. I have lived in the country as well as the city. I have had the privilege of traveling the world, pursuing a college education, and working as a wilderness expedition leader. I have suffered from depression, anxiety, loneliness, and grief. Today's world is hard. For me, having a strong emotional anchor is a firm prerequisite to tuning in to the collective pain that exists. While it may sound absurd, my anchor is a flock of chickens—"my girls." Along with my wider support network of friends and family, my hens keep me grounded.

I am not the only one with a heart full of chickens these days. Backyard chickens are experiencing quite a renaissance. A flock of chickens foraging in the yard may appear quaint and esoteric in contrast with global trade, social media, and the twenty-four-hour news cycle. But it turns out that the once ubiquitous symbol of self-sufficiency and rural ethos is an abiding antidote to

the current blistering pace of life. There is just something about a flock of fluffy chicken butts scavenging in the yard that is undeniably charming. Visit a feed store in the spring and you may find that all the baby chicks are sold out. Type "chicken videos" into the search bar of any social media platform, and you will be buried in content that varies from "how to raise chickens" to "look at the fluffiness of this butt." More and more, people want backyard chickens. But not just as livestock—the idea of chickens as pets and emotional support animals is growing. I think it is safe to say that chickens as a species are trending.

THERE IS JUST SOMETHING ABOUT A FLOCK OF FLUFFY CHICKEN BUTTS SCAVENGING IN THE YARD THAT IS UNDENIABLY CHARMING.

There are many reasons people find chickens alluring. A big one is that they are an important source of food. Their eggs and flesh account for a large percentage of protein consumed worldwide. Historically, humans have thrived on chicken bodies. For those seeking a higher degree of self-sufficiency, chickens are the perfect gateway animal to raise. A significant part of the wave of people buying baby chicks is those who call themselves homesteaders, growing their own food and trying to untangle their reliance on the

consumerism of modern society. Chickens certainly help with this goal. Now, I do not eat chicken meat because it makes me nauseous (perhaps akin to a dog lover eating dog meat). But I cannot deny that I often smugly daydream about how many eggs I would eat in the event of a zombie apocalypse.

Still, there is something deeply gratifying about raising chickens. They are profoundly social creatures, with strict hierarchies that dictate their lives. They are also intelligent and emotional. The derogatory term "bird brain" is a misnomer—many birds, including chickens, demonstrate a comprehension of the world around them, much like primates and dolphins. Chickens form attachments and grieve their lost flockmates. They can recognize and identify up to one hundred different faces, humans included.

That brings me to my last point: chickens as companions. I have formed bonds with my hens like other people have with their dogs. We enjoy each other's company, play games together, and go on adventures. We certainly don't experience emotions in the same way (a chicken's face is very hard to read), but for me, it's easy to see a spark of friendship and affection in their eyes. We have built up a trust that is precious. It reminds me that I am human, it reminds me that there is love out there, and most of all, it reminds me that all of us are interconnected on this planet, feathered and unfeathered.

This book is a love letter to my flock: Bella, Lulu, Charlie, Nixie, Buffy, Juniper, Josephine, Madrona, Penguin, and Nova. I have gained much clarity, calmness, and wisdom from watching them live their lives in the

backyard. They often inspire me so deeply that all I can do is put pen to paper and create colorful art. That is how I started out as an untrained artist in September 2020. I came inside one day and felt compelled to draw my chickens. The process of illustrating their joy and sense of being has become one of the most gratifying and therapeutic aspects of my life. Each individual hen brings so much personality and grace, and I owe all the words and illustrations in this book to them.

Now, is it *really* as easy as that? Find an animal that spends all day rooting around in the dirt and you will become "grounded" too? I can tell you that is *not* the secret, because moles and worms do nothing for me in terms of emotional strength. No—there is a magic about chickens that is elusive yet powerful. Not everyone sees it. You may notice it as you watch a flock of chickens forage after the rain. You may see it in the eye of an inquisitive hen if you get close enough to her. There's a little sparkle there that you might interpret as wanting food, but it could actually be the key to happiness on Earth. I haven't quite figured it out yet. Let me know if you do.

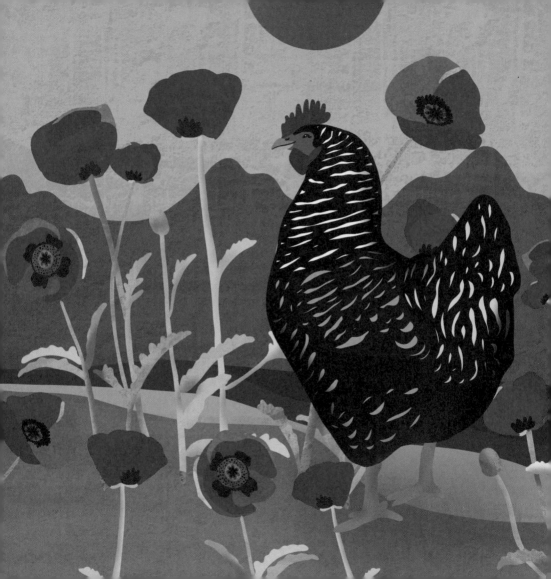

SPRING
Awakening

Spring is a time of awakening for chickens. As the world warms up and begins to bloom after a long rest, chickens greet the new season with energy and gusto.

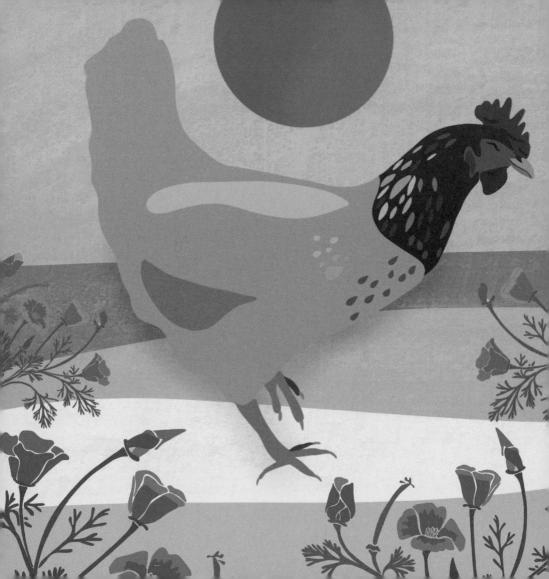

RISE

There is nothing quite like watching chickens on the first warm day of spring. After weeks of chill and darkness, hens can sense the warmth of dappled sunlight and are instinctively drawn toward it. There is a collective sigh of relief as they settle into a sunny patch and feel the warmth on their feathers. Just as we slowly open our eyes every morning to the sun, our feathered friends energetically wake up with the vernal equinox. Spring is a momentous time for us all to thaw out from the long winter.

CREATE

With the dawn of spring comes a cascade of energy. The sun's warmth is animating, and every cell in the body starts buzzing at a higher level of functioning. This solar return kicks off the natural cycle of creation in chickens. After a long hiatus from laying through the winter, their bodies begin to generate again. They are humming with productivity. From chickens, we can observe the natural cycle of creativity and energy. After a long pause from work, we can always find the inspiration to start a new cycle of ingenuity and resourcefulness.

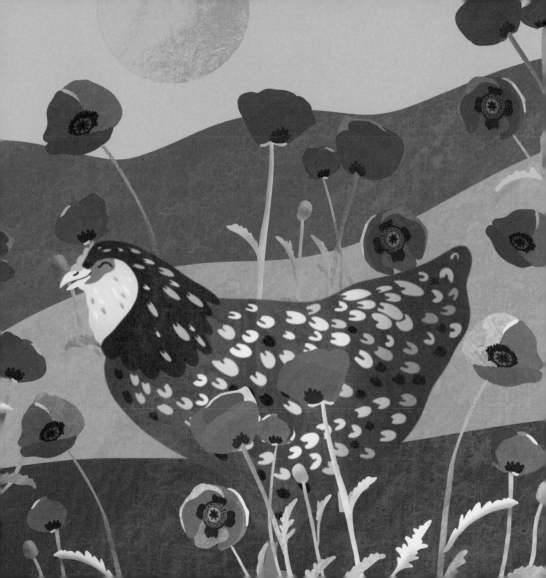

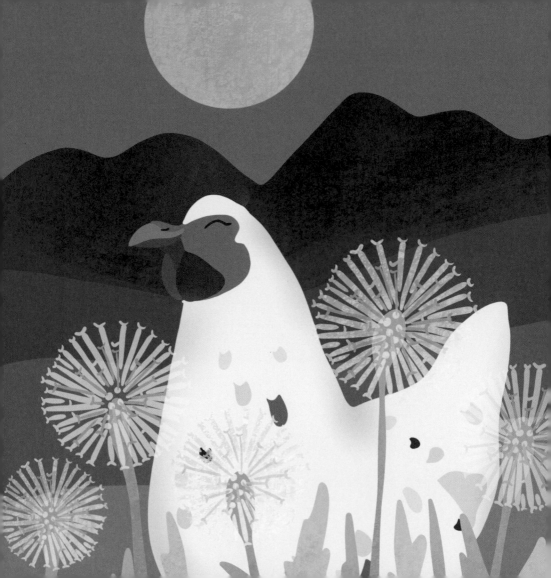

EXPLORE

Chickens are natural explorers. Whatever plot or parcel the flock inhabits, they will survey every inch. *"What, pray tell, is under this brambly bush in the corner?"* If there is a soft patch of dirt to lie in, they will find it. *"Dear me, does this section of fence have a weak spot I can slip under?"* Your neighbor will soon have chickens in their yard too. If you find yourself stuck in a rut or lacking a sense of adventure, remember that you too can explore every inch of your surroundings in search of hidden, joyful gems.

SHARE

With the burst of abundance in spring comes an increased strain on resources. Nowhere is this more apparent than at the hottest piece of property in the backyard—the favorite nest box. Chickens only want the best when laying an egg, and that means lining up or piling on top of each other in the nest box with the best feng shui. Somehow, they wait out the traffic and share their space. When things feel crowded and slow, just remember that even chickens sometimes have to wait in line to lay their eggs.

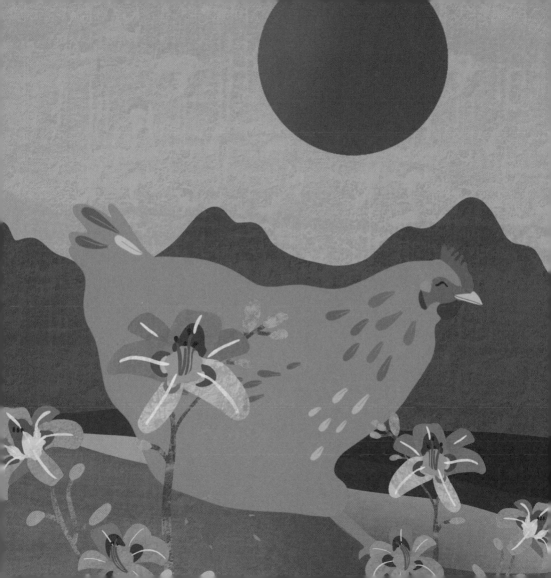

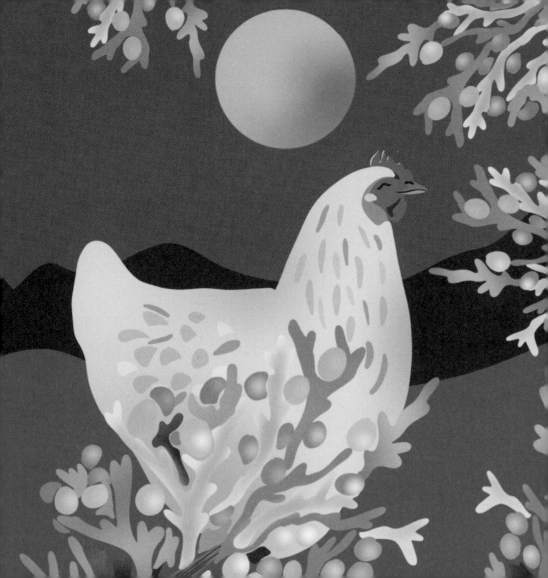

PROTECT

Existing in the middle of the food chain, chickens need protectors in the flock. While they forage, at least one flockmate will have her head tilted toward the sky. Chickens have incredible eyesight and are keenly aware of any out-of-place movements or noises. They also possess a natural sense of guardianship, rooted in strong camaraderie with the flock. There is much to learn from a chicken's vigilant nature. If nothing else, they remind us to be in tune with our surroundings and the dangers that are a normal part of life.

REVEL

Hard work deserves a jubilee. Moments after laying an egg, a hen emerges triumphantly from the coop. She holds her head high and begins her distinctive egg song. Some think it means, *"Look at this beautiful egg I just laid!"* Others believe it's *"I am the queen of egg-laying; no one is better than me!"* Either way, it's a song of pride. Sometimes the entire flock joins in the joyful "bawk-bawking": The yard becomes filled with a symphony of clucks. This is a wonderful reminder to revel in our own achievements. Never let your accomplishments go without a song.

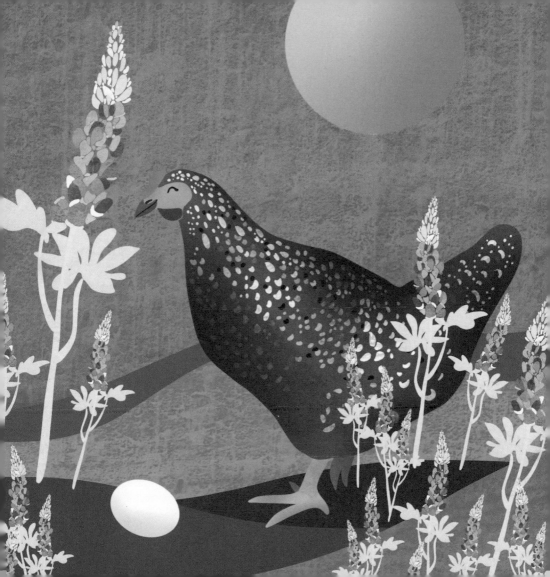

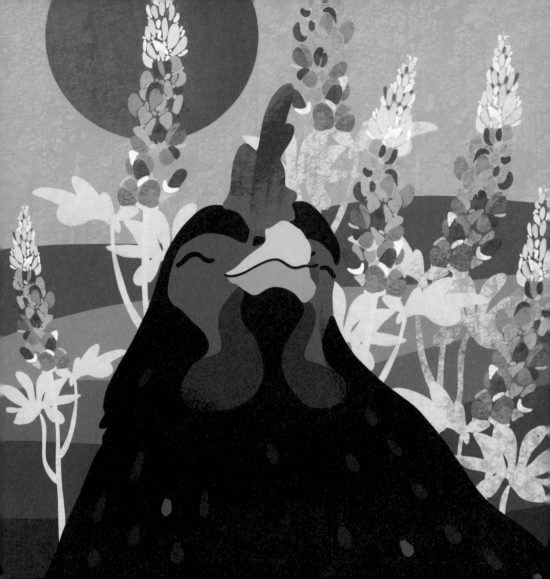

LEAD

Every flock has a leader, a "head hen" who is in charge. She ensures there is enough food and screams her head off if breakfast is served late. Always vigilant, she keeps an eye turned toward the sky. Demanding loyalty from her sisters, she takes the best roosting spot to sleep and always eats first. The head hen's leadership is admirable, preventing the flock from devolving into social chaos. May we also find appropriate times to lead our peers and honor the admirable leaders in our lives.

INSPECT

Nothing gets more judgment than a new item in a chicken's environment. Building a new fence? The chickens will give it the side-eye until it falls down. Installing a fancy new feeder? The flock will scrutinize it for hours until they realize they must accept it to eat. Is there a new freckle on your leg? It is bound to be pecked by an incredulous chicken at your feet. Chickens are masters of curiosity dripping in skepticism.
If you're feeling cautious, that's okay. Feel free to scrutinize your environment as heavily as a chicken does hers.

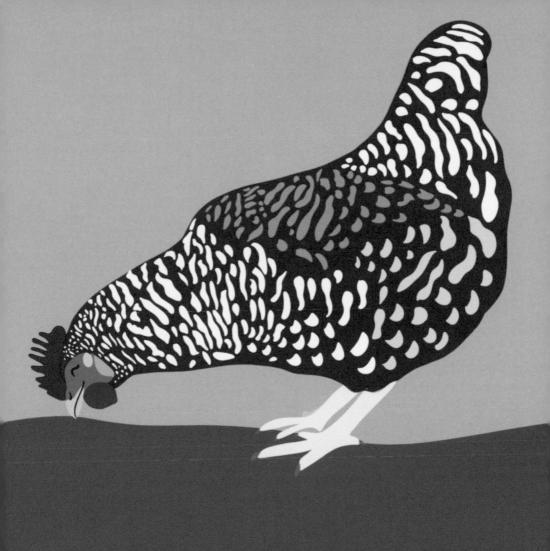

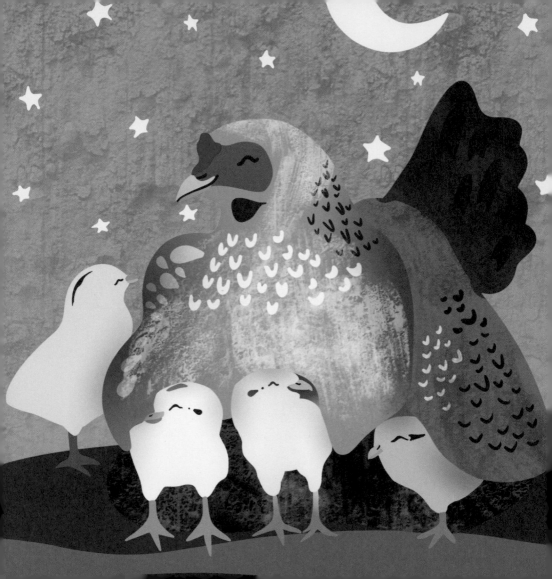

NURTURE

As the days lengthen, egg production picks up and some hens suddenly *need* to sit on eggs. It's instinctual, uncontrollable—an urgency to fulfill a role as mother hen by incubating chicks. This behavior is called "going broody" and is influenced by hormonal changes. Warm eggs against under-fluff is the most gratifying feeling for a broody hen. The drive to cultivate and care for life is a strong and important one. If you find yourself "going broody" like a hen, seek out some life to nourish, whether it be a plant, garden, pet, project, another human, or yourself.

EXPRESS

Self-consciousness is not found in chickens. Independent of any social or cultural self-concept, they express themselves freely all the time. Their joy, anger, sadness, and pain are all apparent. They can be sleepy, brash, obnoxious, graceful, sassy, and majestic—sometimes all within the course of ten minutes. When they look in a mirror, all they see is the reflection of a beautiful chicken staring back at them. We often find ourselves mired in doubt or insecurity; if you can, find ways to mimic a hen's graceful sense of being her full self.

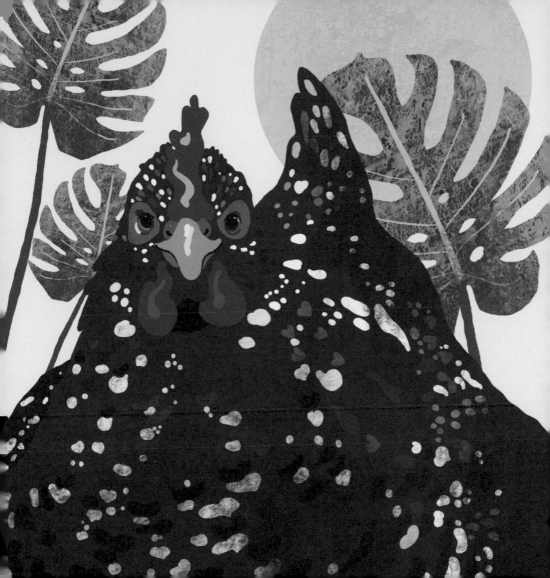

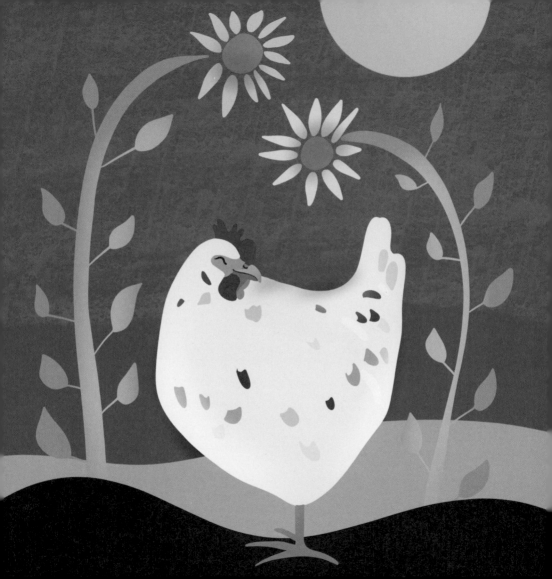

BLOOM

If you have ever watched a seedling grow, you know that it is a wonder to behold. There is often a point where the baby plant hits an incredible growth spurt, suddenly rocketing upward and outward in a burst of joyful exuberance. Watching baby chicks grow into adult chickens is a similar experience. They sprint toward adulthood, their little bodies growing right before your eyes. They have a zest for life that is almost unparalleled in its pep (and cuteness). From them, we can learn what it means to be blossoming and reaching outward in fullness toward life.

INTEGRATE

Anyone who has kept chickens knows that one of the biggest challenges in chicken-keeping is introducing new hens to the flock. There is fierce loyalty and hierarchy among chickens, and each bird works hard to establish her place. When new individuals arrive, it causes social chaos. The process of integrating new flock members is long and important. They learn to share and adapt; new roles are created. It's a beautiful example of growth and transformation. We continually face this need for transformation in the human world, and we can look to chickens to see that it is always possible.

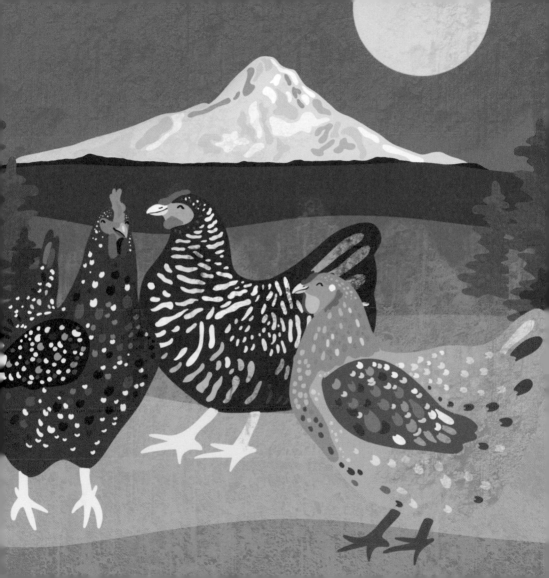

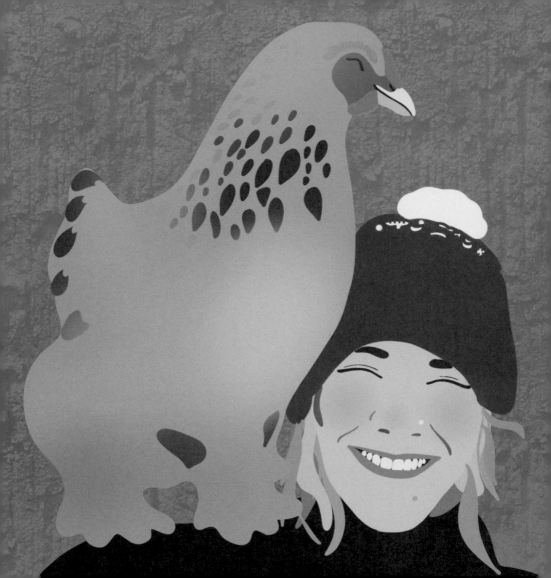

BOND

Chickens are innately social creatures. They bond deeply with flockmates and can form strong connections with their human companions as well. One surefire way to bond with your chickens is by digging in the garden with them. Digging with a shovel is the most efficient method for finding worms that a hen has ever seen! She is used to patrolling the surface for tasty morsels. Introduce her to shoveling up dirt—and the worms trapped below—and she will love you forever. If you find yourself feeling lonely or lost, remember there are many creative ways to connect with your peers.

FLY

As ground birds, chickens dream of flight. While they can propel themselves for short bursts, they aren't able to soar for long. If you have ever seen a chicken bask in the breeze or sit in front of a fan with the wind in their feathers, you know how much they dream of flying. At our house, we take the chickens "flying" from time to time. Our Lavender Orpington, Juniper, is a particular fan of flying. She likes to roost on my bike handles while I ride, feeling the wind rush through her feathers. Don't be afraid to fly!

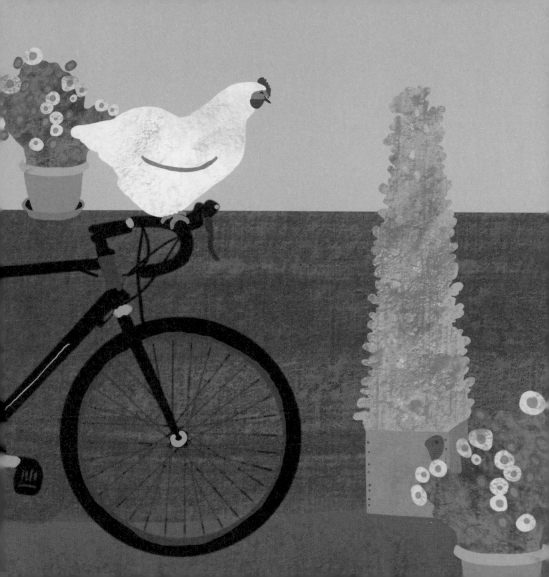

SUMMER
Abundance

Summer is a time of abundance. Flowers are in full
bloom, vegetables are ripening, and the flock basks in
the joyous energy of long days. It is also a time of lazy
relaxation as chickens acclimate to the heat.

ATTUNE

Chickens are in perfect harmony with their environment. As the days lengthen, they wake up earlier and stay up later. As vegetables grow, they eat seasonally from the garden. And as the weather heats up, they acclimate to the heat and practice cooling themselves. Summer is a perfect time for joy and play as we transition from the energy and awakening of spring. If you find yourself feeling disconnected from your environment, take a leaf from a chicken's book and take a break to attune yourself to the wondrous natural cycles around you.

CONNECT

Just like humans, chickens are social animals. Social hierarchies rule their lives. A chicken needs connection to thrive, which is why the flock is such an important structure. Hens often spend hours roosting together in the shade, cooing back and forth as they nap. They also take turns preening each other, cleaning hard-to-reach places around the face. A chicken rarely thrives on her own. Remember the great power in connection if you are feeling isolated or alone. Do not be afraid to go out and find your flock.

BASK

A chicken basking in the sun is a beautiful sight to behold. She plops herself down on one side and extends a wing like a solar panel. Then, she ruffles her feathers to get as much surface area in the sun as possible. Finally, she closes her eyes in complete bliss. If you didn't know better, you would think she was photosynthesizing. Some people believe chickens do this to rid their feathers of parasites and mites. Whatever the reason, they definitely enjoy it. The lesson here? Find spots of sun when you can and plop yourself down.

PROCLAIM

With the extra exertion of energy the summer brings, chickens need more calories. Compared to the winter, their every movement is more powerful, vibrant, and full of life. This means that they are in constant need of food. And with the extra abundance all around them, chickens get accustomed to daily feasts. A common noise from the backyard in the summer is a not-so-subtle scream for snacks. If you find yourself in need of something with your whole being, do not be afraid to wake up the entire neighborhood to demand it.

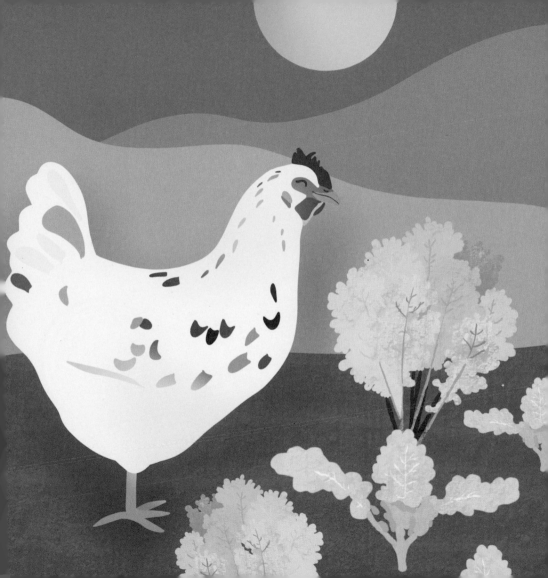

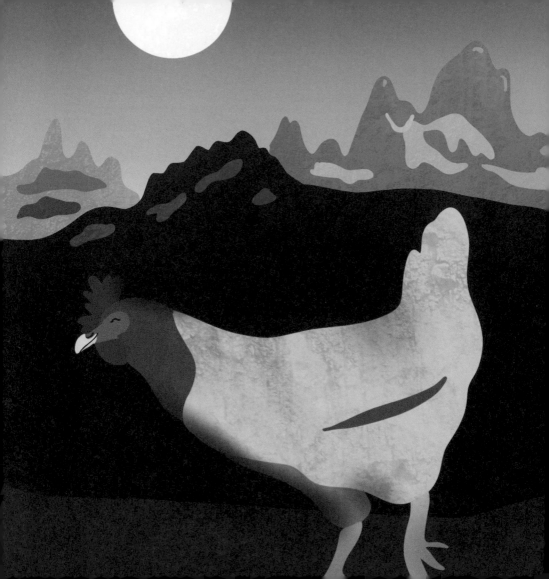

ACCLIMATE

Chickens work to stay cool. With their insulative feathers and 106°F (41°C) basal body temperature, they prefer the cold to the heat. Luckily, they have ingenious strategies for staying cool. For example, they release heat by panting with their mouths open and holding their wings away from their bodies. They also dig down into the earth and lie in the coolness of the dirt. They drink more water and find a breezy spot in the shade. If you find yourself having a hard time cooling off in the summer, remember to hydrate in a cool spot.

PLAY

With the joy of summer comes playfulness. A flock at play is a sight to see. Chickens sprint across the yard for the sole reason of gaining speed and feeling the wind on their faces. Sometimes they flap their wings, jump, or even perform martial arts-like moves in the air. There is unbridled joy in a playing chicken. She loses herself in the moment and throws all cares to the wind. Summer is also a time for play in the human world. If you find yourself weighed down by worry, take a joyful lap around the backyard.

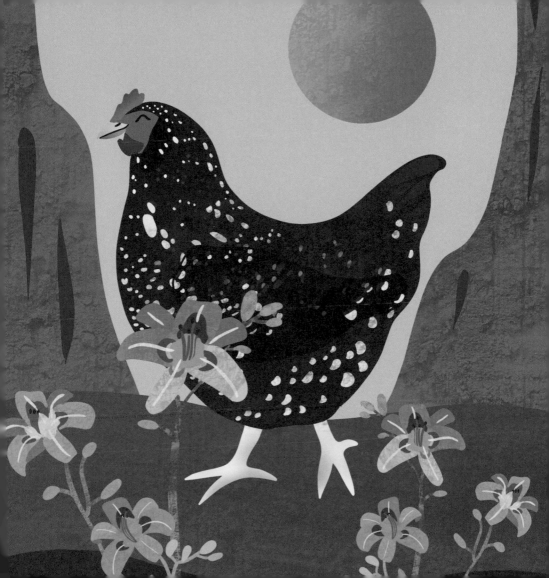

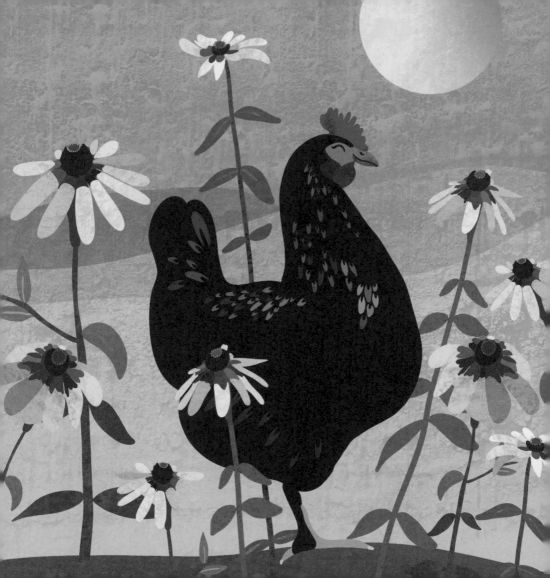

APPRECIATE

Since they live out in the elements, chickens viscerally feel the changes in the seasons. Their bodies adapt to each transition, their energy levels fluctuate, and they experience the cycles of nature alongside the flora and fauna. Summer is a time of abundance, and it's easy to see their appreciation for it in their play, relaxation, and energy. A sparkle of appreciation runs through it all. Practicing gratitude is one of the simplest things we can do to find peace. Take after a happy hen and appreciate the little things.

PURSUE

Chickens are natural hunters, taking great pleasure from the chase. If you have ever seen a chicken sprint across the yard after a mouse or a snake, you have seen that joy in action. It's more than joy, though. It's instinctual, predatory—harkening back to their prehistoric roots. The moment something tasty catches their eye, a chicken is already in hot pursuit. These feathery predators have much to teach us about seeking joy and completeness. By their example, we can learn not to hesitate in the pursuit of our dreams.

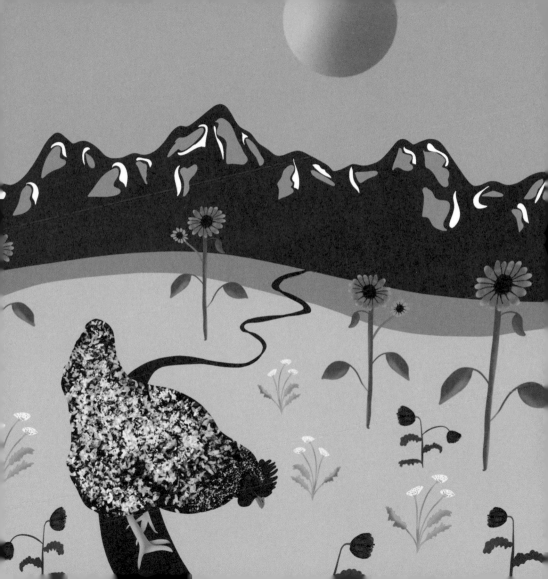

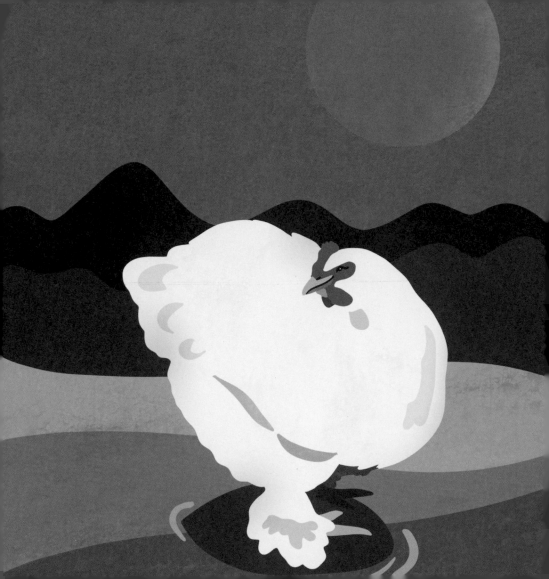

HYDRATE

Chickens are masters of hydration. Laying eggs is a water-intensive process. Without fail, a hen will emerge from the nest box and drink heartily before proceeding to sing her egg song. Chickens also find water in the most creative places: a dripping hose? *"Yes, please!"* A muddy puddle in a secret divot in the lawn? *"Yum!"* Rainwater on a leaf? *"The best!"* Water consumption is one of the keys to life on Earth, especially during summer. Don't forget to treat yourself with water and always drink extra in times of great effort.

ASTONISH

Chickens are truly astonishing creatures, full of surprises in their intelligence, emotional capacity, and dinosaur-like behavior. People are continually taken aback by their gorgeous feathers, rainbow eggs, and inquisitiveness. At our house, we have a few even more astonishing chicken feats. Our Buff Orpington, Buffy, likes to paddleboard! She plops down on the deck and lets me paddle her around the lake. She always reminds me that it's possible to defy expectations. You don't have to be locked in to what others expect of you.

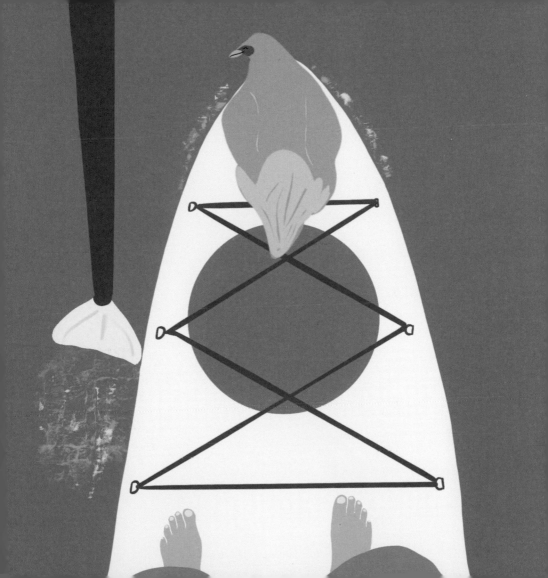

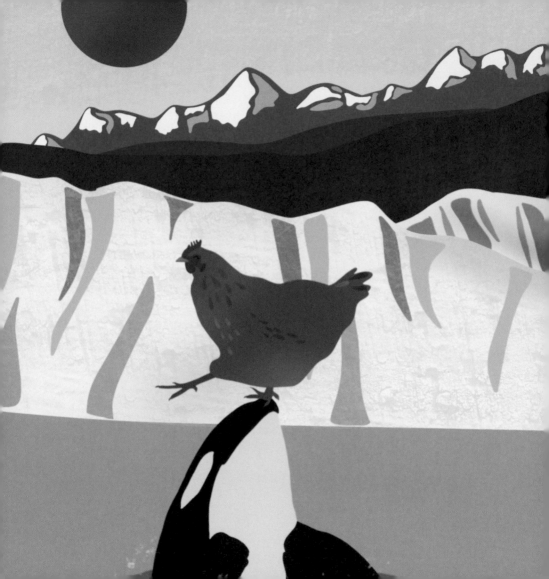

DAYDREAM

Ever wondered what a chicken dreams of? It's true—chickens do dream! Deep in the dog days of summer, you may see a hen nestled into a shady spot with her eyes closed. She might coo periodically in perfect contentment. In her mind are vivid daydreams of soaring high in the sky, snuggling with her friends, and eating the largest, tastiest worms in all the universe. Dreaming is one of the most unself-conscious things we can do. We let go of our doubts and let our ideas run wild. Don't be afraid to daydream your way to perfect contentment.

DANCE

There is a whimsical nature to hens that is slightly elusive. It's in the sparkle in their eyes, the sassiness of their waddle, and the fluffiness of their perfectly pressed pantaloons. In my mind, this whimsy makes them perfect dancers. I often dance with my hens, picking them up and twirling them around the yard. I also hold them and bump their little bellies to the beat of a song. And the rhythm of their strut cannot be ignored! It is guaranteed to make you smile, having a yard full of tiny, fluffy dancers.

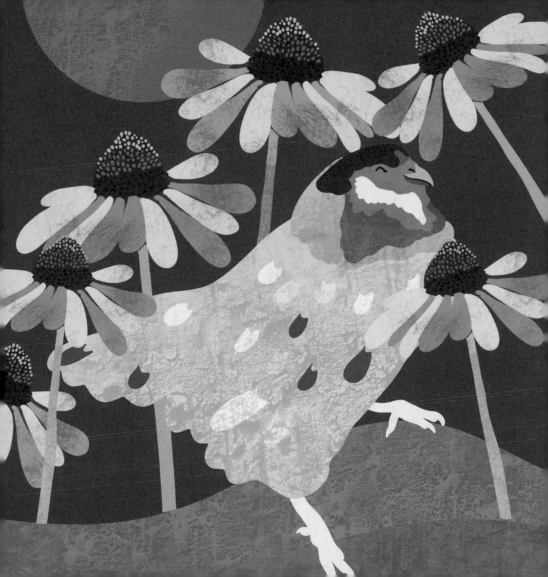

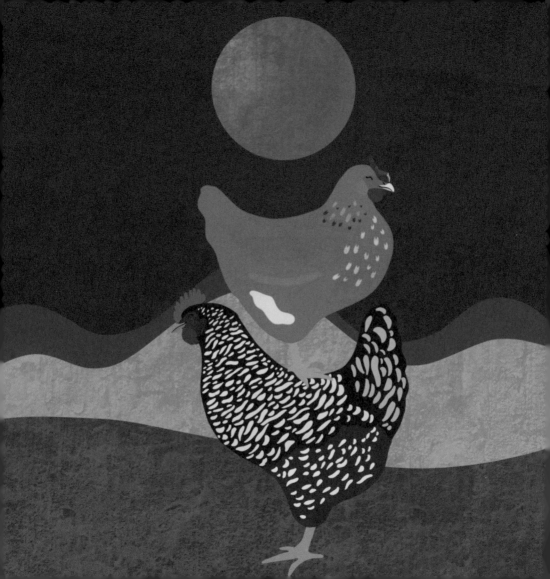

COLLABORATE

Observe chickens for any length of time and you may find yourself wondering if they are plotting to take over the world. Hens often meet in circles and cluck to each other as if they are planning something. *"Is it a mutiny?"* you wonder. *"Are they planning a prank?"* Or perhaps they are just discussing the merits of yellow mealworms over black soldier fly larvae. If you find yourself astray in a world of never-ending tasks and distractions, anchor yourself with some slightly mischievous plans with friends. Where would we be without our closest companions and accomplices?

AFFIRM

One of the most admirable qualities of a chicken is her ability to strut her big, fluffy butt. She is unself-conscious about her size or the space she takes up. This world is full of expectations—how we look, dress, and act. It all seems to be predetermined by forces beyond our control. But it isn't so. Just as a chicken is born into her body and struts her fluffy butt for all she's worth, we too can have the freedom to be ourselves in the bodies we've been gifted.

FALL
Preparation

Fall is a time of preparation. Everything must transition from abundance to scarcity. For chickens, feathers must be regrown for the long winter, and life's tempo begins to slow down.

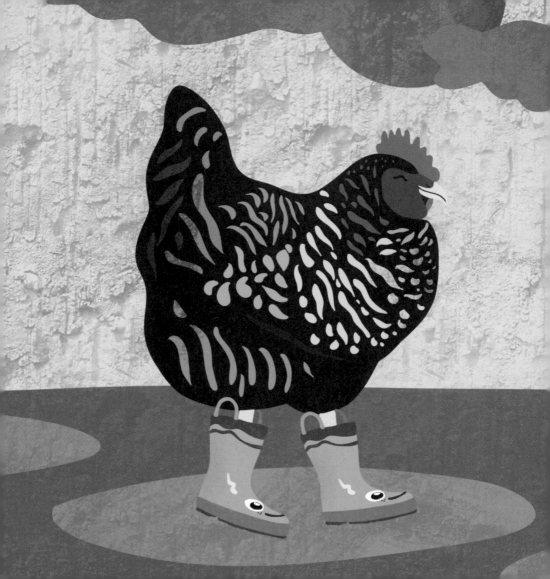

ACCEPT

As the season changes from warm to cool, chickens' bodies undergo yet another transition. As rain starts to fall once again, they calmly accept the precipitation and prepare themselves for another season of wetness. More rain means more worms, so no one is actually that mad! They just make sure to give enough time to dry off before bedtime so nobody gets chilled. If you find yourself disheartened by the end of summer or decrease in sunshine, just remember that there are small joys to be found in the rain, too.

PREEN

One of the most important behaviors of all birds is preening. It is imperative that they preen their feathers daily to keep themselves clean—and also to preserve their insulation and health. Preening is a meticulous act, where each feather gets cleaned and put perfectly back into place. All a chicken has to do to fix her feathers is to run her bill along the feather to get the hooks to align once again. Likewise, finding a skincare routine that works for you is not only fun and pampering, but also healthy.

RESET

In terms of cyclical changes, molting is one of the most significant resets in the animal kingdom. Every fall, birds drop their feathers to grow new plumage. Their feathers have taken a beating from the past year, and it's time to regrow anew. It can be quite dramatic, seeing a chicken with hardly any feathers left. But each hen takes it in stride. Just like seeing a phoenix rise from the ashes, chickens return to their full-feathered glory each year after the molt. We can take great solace from knowing that this transformation is possible.

BREATHE

Gardeners with chickens know that they are great for building soil. Their scratching and pecking naturally aerate the earth, increasing oxygenation and the overall viability of the land. Another way to think of it is that chickens help the Earth breathe. The natural cycles around us are larger than we could ever imagine—the water cycle, the respiration cycle, the nutrient cycle—and yet we fit quite perfectly within them. Connecting with the breath is an age-old art form of self-care. Every time you take a breath, it's an opportunity to remember that the Earth is also breathing around you.

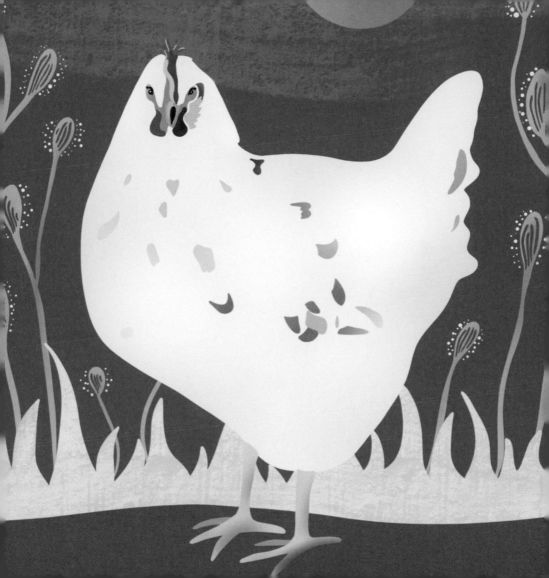

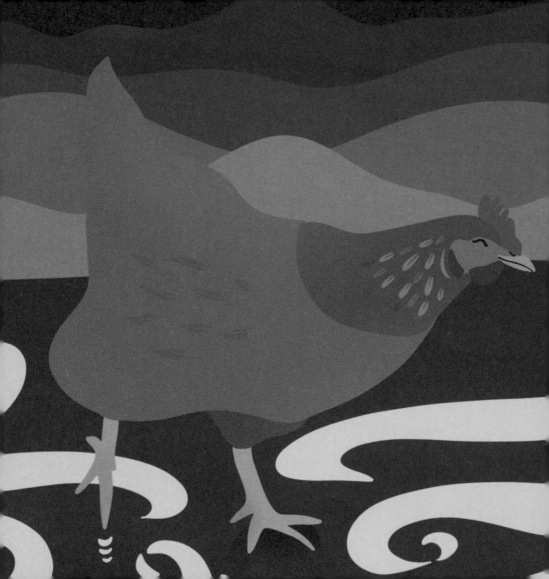

BALANCE

Chickens are better designed for balance than humans. The structure of their feet and legs allows them to perch for extended periods, even while sleeping. To scratch her face, a chicken must stand on one leg while bringing the other up to her head. Considering the roundness of their bodies, this is a particularly impressive feat! As light and energy subside during the fall, it's good to remember the importance of balance amid change. Just as a chicken stands on one leg through a rainstorm, you can maintain stability through the transformation.

ENRICH

Fall is the best time to enrich the soil, allowing it to rest over winter and be ready for new growth in the spring. Chickens play a key role in fertilizing the land, as their droppings are particularly nutrient-rich. I love to let my hens roam the garden beds in the fall, giving them free rein to do their favorite thing—destroy! I know that from the destruction will come great regeneration in the next growing season. In the slowing season before a great rest, remember the importance of nourishing the environment around you.

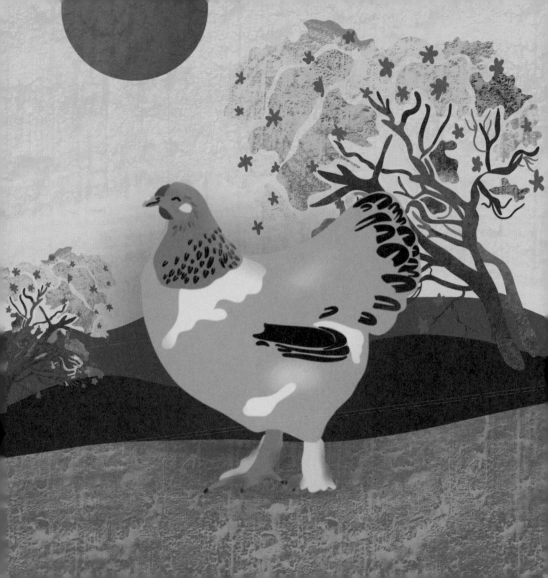

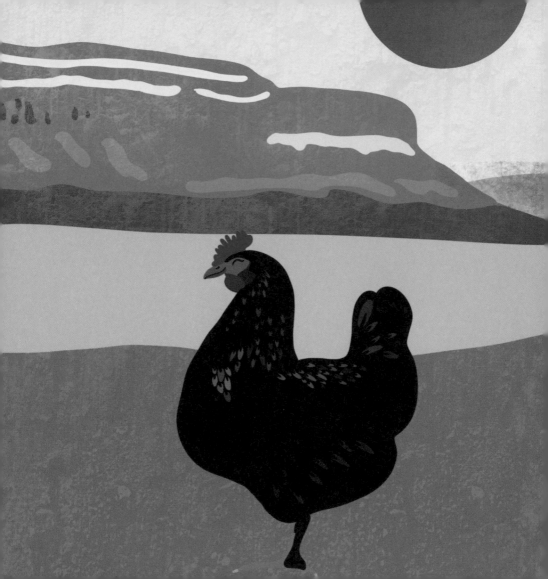

CONFRONT

It is certainly not always harmonious in the chicken coop. Chickens constantly remind each other of their places in the pecking order. Hierarchy is a constant reality, determining who gets to eat first and who must wait. To some, this daily confrontation is hard to watch. But conflict is a constant for humans too, and it's important to confront rather than avoid. The pecking order is one of nature's ways of showing us how power plays out in the world. Approach it with a big, loving heart, accept its existence, and stake your claim to the pecking order when necessary.

ROOST

As ground creatures, chickens have a natural instinct to get off the ground at night, out of reach of nocturnal predators. In addition to safety, they roost to gain a new perspective on their world. You will often see a hen roosting in the middle of the day, surveying her territory between preening or naps. To roost is to obtain an aerial view of your surroundings while also enjoying a comfortable breeze on your underbelly. If you find yourself in a rut, you can always seek out a lofty new perch from which to ponder all your options.

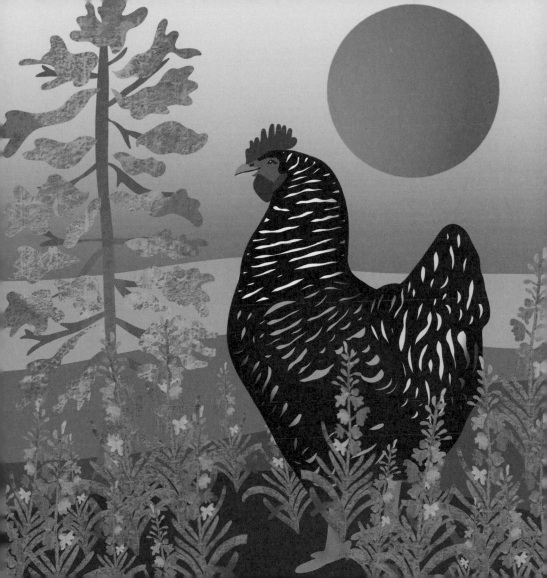

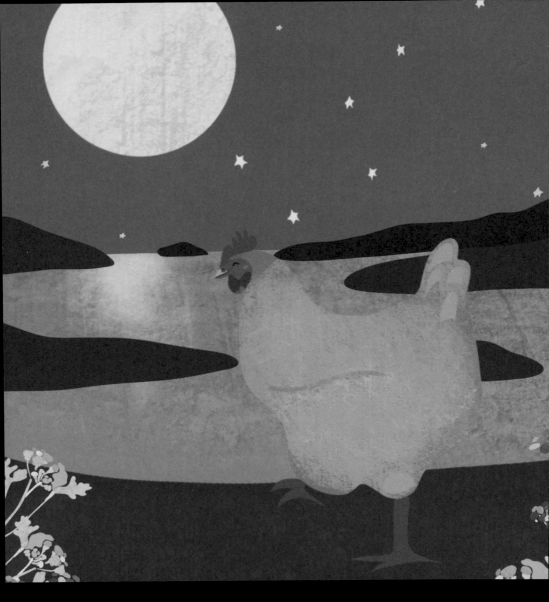

SURRENDER

Chickens descend from a time when bird-like reptiles ruled the world. Mammals developed night vision to roam safely while dinosaurs slept; as descendants of dinosaurs, chickens' brains shut down in the darkness. A surefire way to calm a chicken is to put her in a dark, cool spot—she will immediately fall asleep. In our world of never-ending tasks and to-do lists, this is a magical skill. When things pile up and your brain is too full, just imagine you are a chicken. Take yourself to a dark, cool spot and surrender to the wonder of a quiet dinosaur brain.

RECYCLE

One of the many wonderful things about having chickens is zero food waste. Extra food and veggie scraps all get piled on a plate and marched out to the coop. Your chickens, having learned that plates and bowls carry offerings from the kitchen, will chase you down at the sight of their feast. Their perfect little bodies take all that food waste and recycle it into nutritious fertilizer for the land. If you keep a garden, the cycle of soil, vegetables, chickens, fertilizer, and back to soil is a beautifully harmonious Earth system playing out in your backyard.

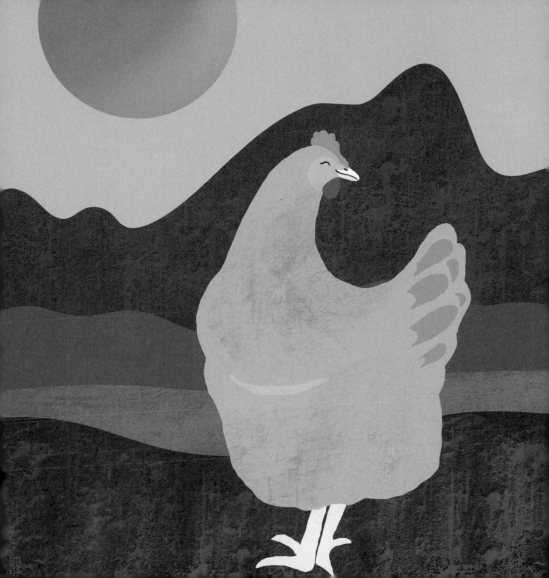

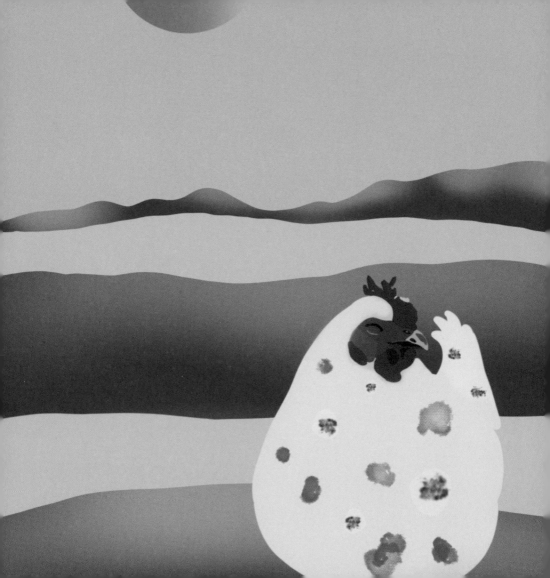

BURROW

Where you see a backyard, your chicken sees an opportunity for burrowing. Chickens and potholes go hand in hand. They love nothing more than to make perfectly chicken-sized indentations in the dirt. They love having their bodies close to the earth, whether in search of bugs or just to get some dirt in their feathers. This is a chicken's way of connecting with her territory. Even as the seasons change and the days get shorter, it's important to continue connecting with the land like a chicken burrowing in the dirt.

PECK

Anger is a natural part of life, and its healthy expression is an important therapeutic release. Chickens use their beaks to show anger and maintain their boundaries. Whether keeping their flockmates in line or hunting down a meal, a swift peck usually comes with a burst of adrenaline and some loud clucks. It's important to release these feelings in life. Emotions come with energy, and that energy flows best when it's not restricted. As long as anger is not directed at another being, it is healthy to liberate it from your body.

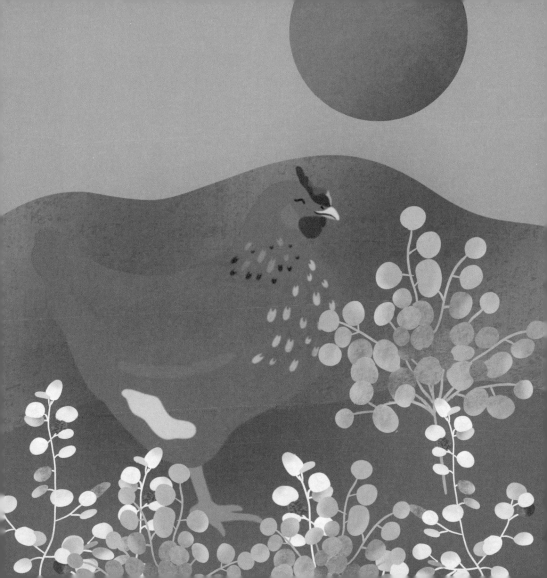

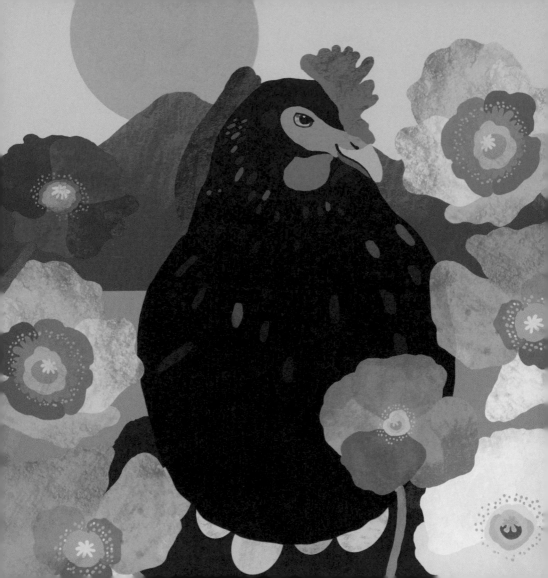

NEST

A chicken loves to be snuggled into a safe, enclosed space. Whether in the coop laying eggs or a soft hideout under the branches of a bush, the instinct to nest is strong. As fall descends on the backyard, the nests become even safer and cozier. Chickens are preparing for winter. In this time of transition, you may feel yourself called to seek refuge. Perhaps it's being bundled in a blanket on the couch or swaddled in the embrace of a big, chunky sweater. Whatever your fall nest is, accept it as preparation for the coming season of rest.

REFLECT

In the evening, as dusk falls, the flock gets nestled in for the night. If you stand close, you'll hear a gentle swishing and rustling as they settle onto their perches. Once they find their spots, nightly court is called, and they begin to debrief their day. The weather is discussed, as is the quality of the worm haul. Any predator sightings are recalled, and issues with the pecking order are examined. Reflection is one of the best tools we have for learning, as it allows us to synthesize our experiences and make sense of our feelings.

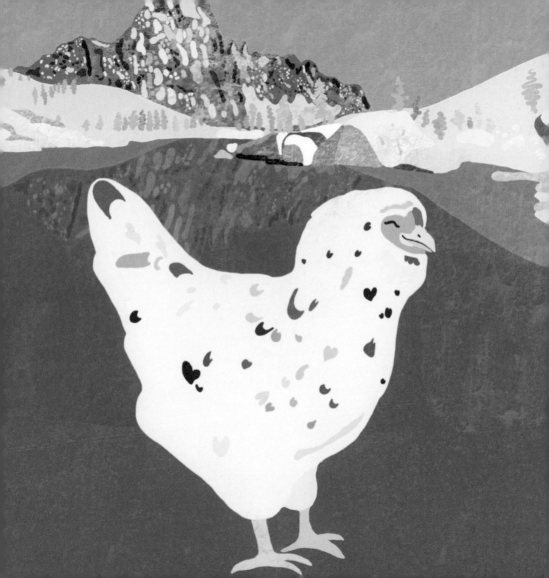

WINTER
Rest

Winter is a quiet time for chickens. As cold descends on their world and the days grow shorter, they spend their time conserving energy and finding rest amid the wind, snow, and rain.

EBB

Where summer is a time of flow, winter is a time of ebb. Energy recedes along with the length of the days. For chickens, this means taking a break from their most arduous work—laying eggs. Egg-laying is catalyzed by the sun, so shorter days trigger a chicken's body to stop laying. Just as humans get a break at the darkest time of year, chickens get an egg-laying holiday. If you have ever experienced an ebbing tide, you may be familiar with the gentleness with which nature's cycles recede. Winter is a time to ease into your ebb.

ENDURE

Chickens are an incredibly resilient species. As winter weather descends into darkness and cold, chickens hunker down to endure it. They can withstand cold temperatures that would send humans into hypothermia with ease. By puffing out their feathers, they create air pockets near their skin to trap heat. They tuck their faces and feet away beneath their wings to avoid frostbite on their combs and wattles. Their resilience is an inspiring reminder that we, too, can withstand difficult things. Sometimes you just need to hunker down, fluff up, and tuck your head under your wing.

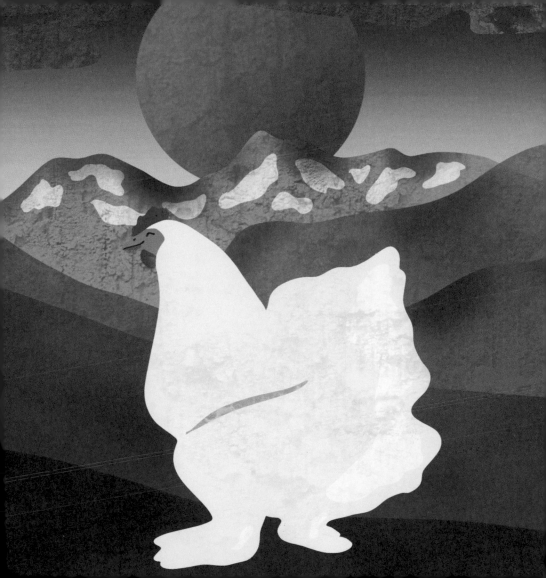

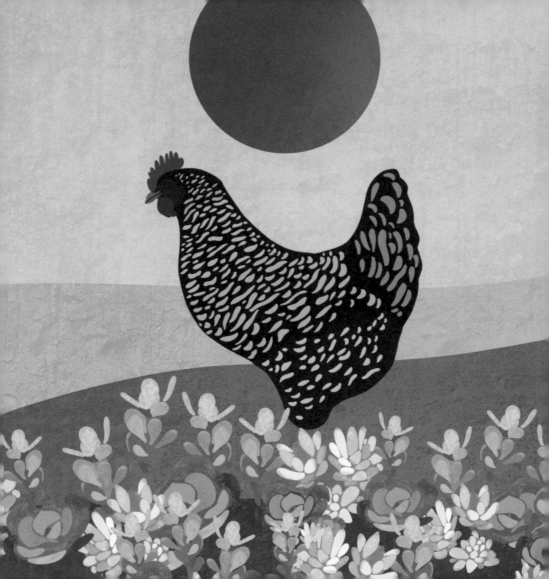

HONOR

Chickens have formidable roots. Their talons are reminiscent of those that once walked the Earth, bearing the weight of apex predators. As the dinosaurs of our time, they have a significant legacy to uphold. Although they are much smaller than their fore-feathers, they carry the responsibility with dignity and grace. Watch a chicken hunt for five minutes and you may get an inkling of how a velociraptor moved. Chickens can tie us back to a long-lost time, giving meaning and depth to the past. From them, we can remember to have reverence for those who went before us.

FORGIVE

With all the spats chickens get into over the pecking order, it is imperative that they can resolve this to continue living together as a flock. Moving through conflict is another important aspect of life. Chickens can peck at each other over the best sleeping spot, then come together to snuggle during the cold night. A sense of trust develops when you can move through conflict in this way. If you find yourself stuck in hostility, think of the chicken's ability to forgive her flockmates after squabbles.

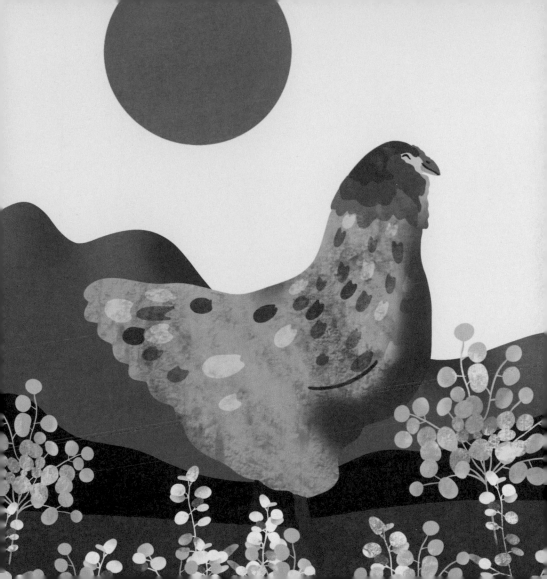

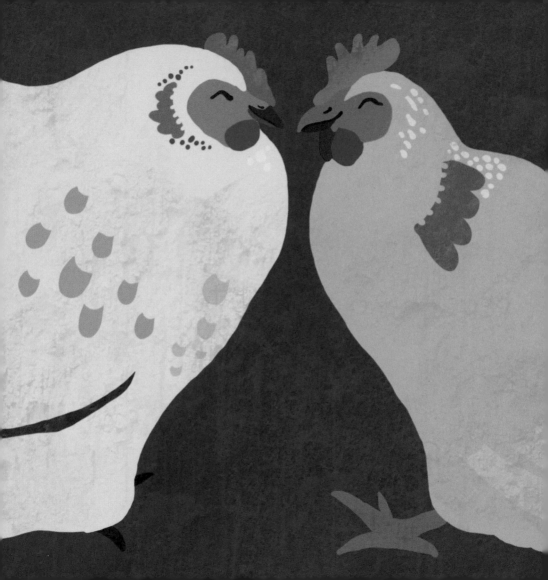

RELY

Chickens rely heavily on their flockmates in the winter. Their clucking company breaks up the monotony of cold days, and their collective body heat warms the coop at night. In the snow, they work together to trample down a path to access food and water. This reliance on their team is one of the greatest examples of grace that chickens can teach us. Community can help us get through the hardest times. Winter can be a period of challenge and isolation. Don't forget to rely on your flock in times of struggle.

GRIEVE

All chicken flocks will experience loss—a chicken's life cycle can often feel much too fast. Losing a flock member has a big impact, and chickens grieve just like many animals do. They can often be seen looking for their lost flockmate, or they might go through a period of withdrawn depression. My flock stopped laying eggs for two months after their sister, Penguin, died. Grief can come into sharp relief in the winter, when life is at its most receded. Mourning is one of the most important feelings of all, as it connects us to what we love most.

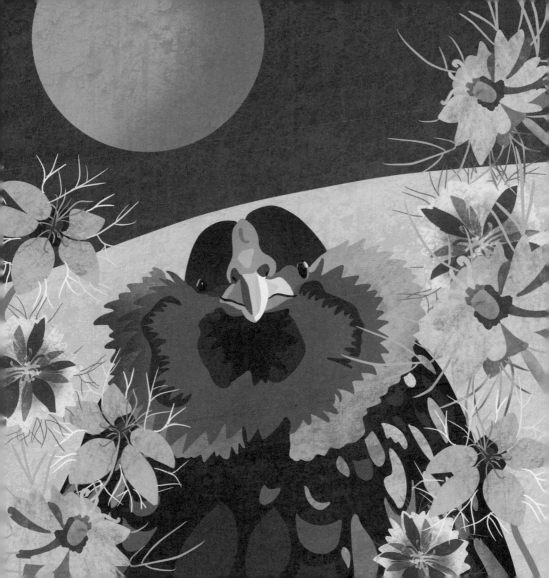

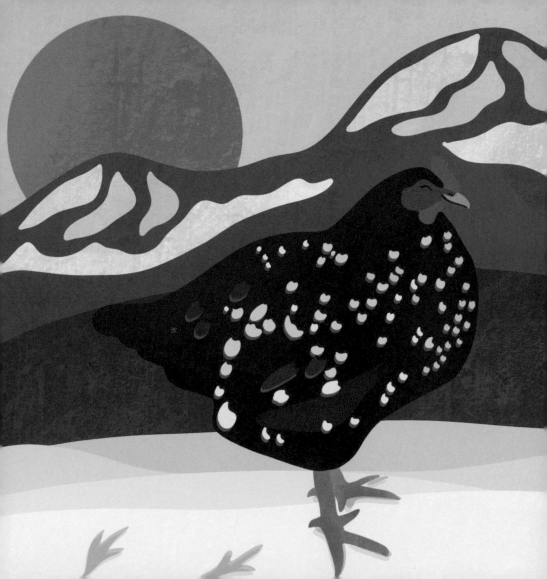

OBSERVE

A chicken has exquisite eyesight. She can spot a wriggling worm in a pile of dirt from a yard away. She can pinpoint a hawk out of the corner of her eye and send up the alarm before any nearby human notices. Chickens spend much of their day in surveillance mode, processing their external environment through sight. If you find yourself lost in the hum and drum of life, remember the wisdom of simple observation: no need to react, respond, or even process. Just resting and taking in your surroundings can be enough.

LOAF

Chickens are queens of loafing. It is their specialty to fluff up and laze the day away. In winter, they are especially impressive loafers. With the cold weather, they fluff their feathers out more than seems possible and make themselves appear twice as large. Humans often forget that nature slows down in the winter. Our pace sometimes even picks up with the holidays. Chickens are here to remind you that it's normal to slow down and be a couch potato in the dark months.

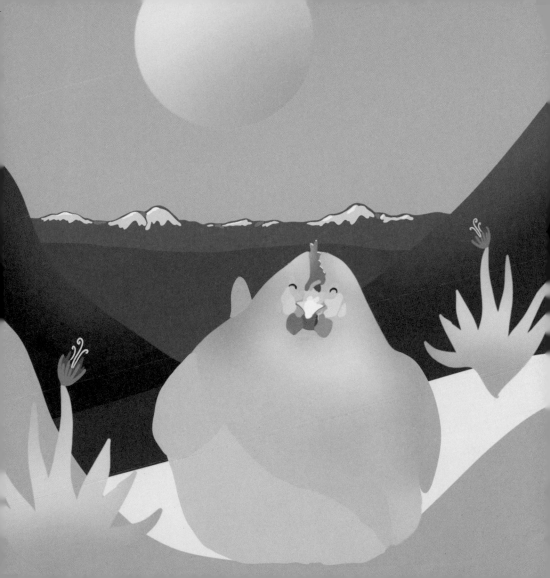

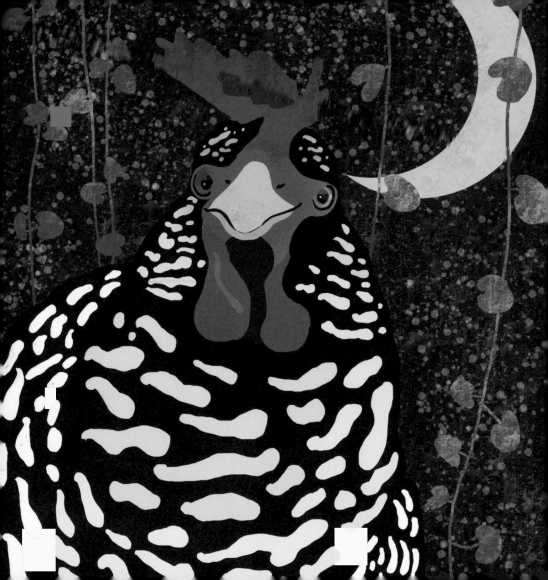

RETREAT

Lucky for us, chickens are not part of the human "rat race." They understand the wisdom of retreat in the face of challenge. For them, it is often a big windstorm or blizzard. On those days, the flock will often refuse to leave the coop to preserve their body heat. Sometimes, it is just too much to engage with the windstorms and blizzards of the world. You do not always have to be moving forward. Especially in times of low energy, a retreat is often the best thing you can do for yourself.

NESTLE

Snuggling with your loved ones might be one of the greatest pleasures in life, and chickens agree. You can often find them fluffed up in close proximity to one another. Partly, this huddling together is for warmth. But there is also a deep camaraderie that comes with enduring winter as a community. Each cold season, I find that my hens have become closer than ever. Their conflicts ease, and they operate more as a cohesive unit. Winter can be an austere and lonely time. Fend off its isolation by nestling in close with your loved ones.

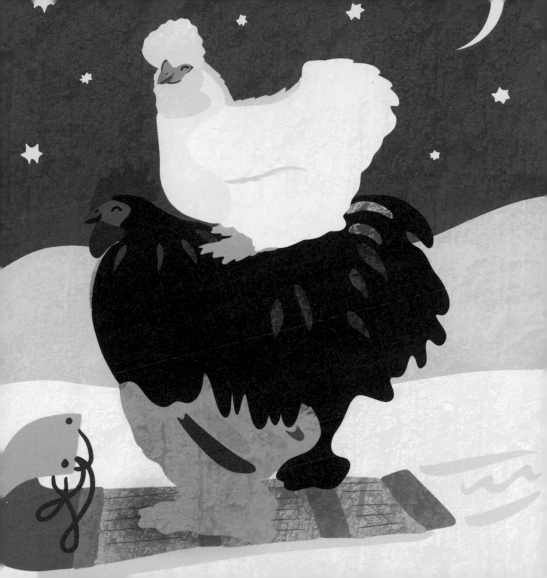

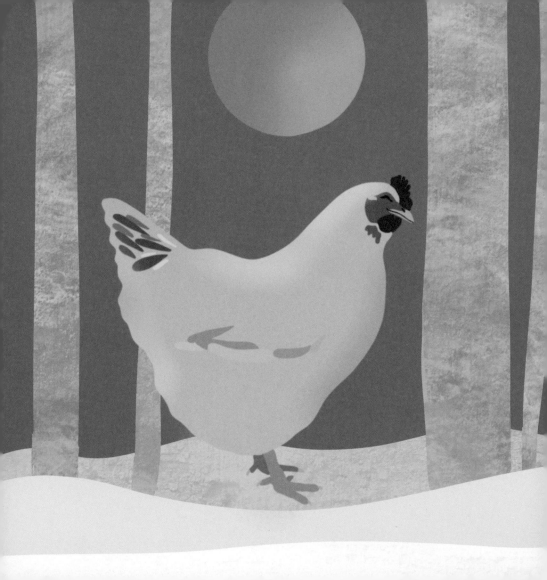

ADVENTURE

Although winter is a time for retreat, some prefer to be out in the cold. Chickens, too, can enjoy winter. Juniper, the Lavender Orpington, loves the snow. Her nickname is "The Yeti" because of how joyfully she tromps through snowdrifts up to her neck. On special days, I zip her up into a small backpack, and she gets to join me on short ski trips! If you're someone who needs a little extra adventure in the winter, Juniper is here to remind you that it can be blissful to slide around on some snow.

COO

In sharp contrast to the exuberant jubilee of the egg song, chickens sometimes lightly coo themselves to sleep. It's a gentle, whimsical tune that usually consists of a slight whistle on the exhale. If you're lucky enough to hear it, you'll know that it's one of the cutest, most heart-melting sounds on the planet, full of innocence and simplicity. As one chicken starts to coo, the others respond in turn. Soon, you'll have a whole coop of softly trilling, almost-sleeping chickens, creating pure peace on a dark winter's night. Chickens remind us of the importance of having a soothing wind-down routine before sleep.

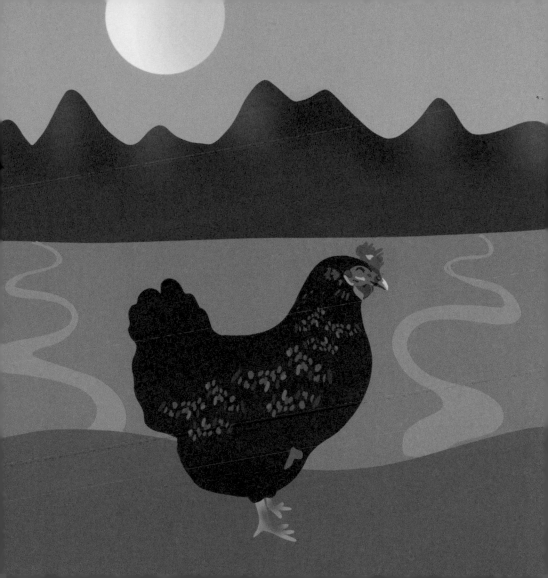

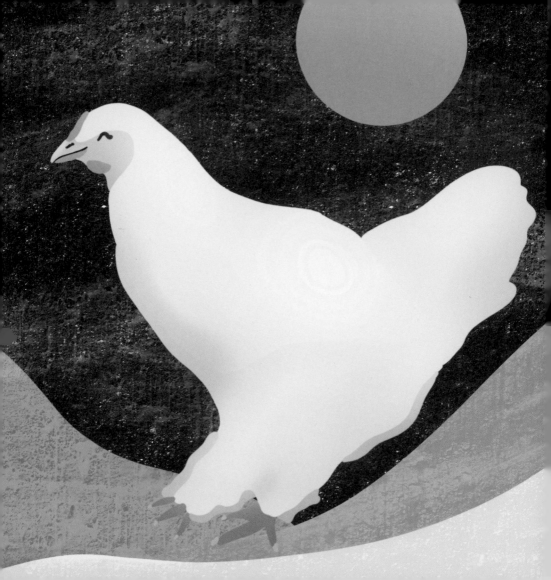

ROUSE

All that loafing and resting can cause stiffness, and chickens know the importance of shaking off dust. One of the most common behaviors seen in all birds is the quick fluffing out of their feathers. This is called rousing. Chickens rouse often, whether to shake out a dust bath or wake themselves up. It's an incredibly cute sight, but it serves an important energetic purpose too. Resting and retreating can cause joints to get stiff and achy. Don't let the dust settle too thickly. It is always important to shake out your body and mind to preserve nimbleness.

REJOICE

Even on the darkest of days, a chicken will practically do a backflip to get a treat. She may be having an awful day—perhaps she was pecked by her sisters or got the worst dust-bathing spot—but she will still find unbridled joy deep inside herself at the sight of a dried mealworm or a piece of cheese. The dark months can be difficult, full of chills and setbacks. If you find yourself needing some strength of mind, imagine you are a chicken getting a mealworm. Immense feelings of happiness are still possible amid the gloom.

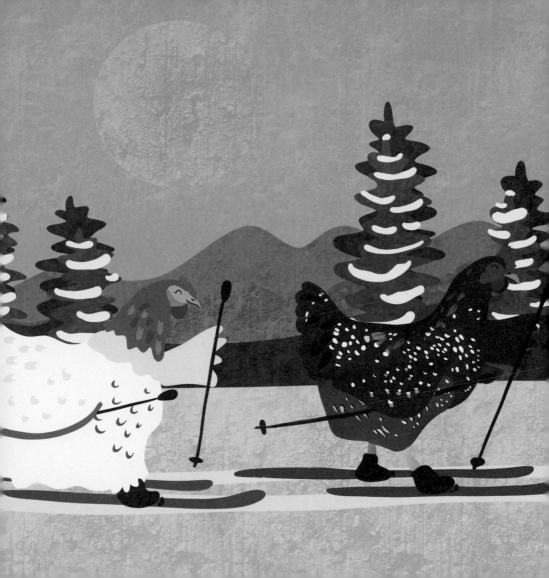

FLOCK BIOGRAPHIES

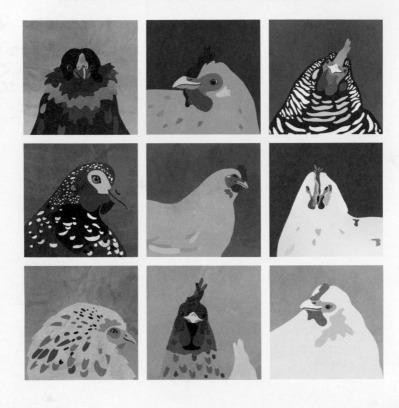

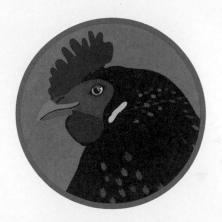

BELLA

Bella is our four-year-old Black Copper Marans hen who ranks first in the pecking order and lays deep chocolate-colored eggs. As our head hen, she maintains the all-important social structure of the pecking order. Bella is a benevolent leader who has learned over the years when to give a gentle warning and when to step in with a firm peck. She is also the shepherd of the flock. Since we don't have a rooster, she assumes the role of guardian. Her eyes are almost always peeled toward the skies, and it's her clucks of warning that are heard most often to warn the flock of an incoming threat. She is affectionately known as "Belly-Bell."

LULU

Lulu is our four-year-old splash Swedish Isbar hen who ranks second in the pecking order and lays greenish-blue eggs. Lulu is the most talkative of the flock, and she especially likes to complain loudly when snacks are scarce. She and Bella are best friends and they can often be seen foraging or roosting together. Lulu's position in the pecking order is due to her friendship with Bella, but she doesn't really fulfill any other leadership duties—she prefers digging in the dirt. Lulu is the hen most likely to be up to her head in dirt looking for worms. She is a rare breed with a natural talent for plundering the yard for food, and she has taught the entire flock how to be expert foragers. She is lovingly called "Luey."

CHARLIE

Charlie is our three-year-old Barred Rock hen who ranks third in the pecking order and lays large tan eggs. She is the bulkiest hen in our flock—with an equally bulky personality. She often plays the role of the "enforcer," keeping younger hens in line for the head hen, Bella. She likes to think she's apprenticing for the top position, but there's still much to learn before she gets there. Charlie gets called "Charles" when she is being too aggressive about food, which is often. To her dear credit, Charlie is also the most snuggly chicken in the flock. She enjoys being held, cradled, swaddled, and getting head scritches.

NIXIE

Nixie, our three-year-old Sapphire Olive Egger hen, is fourth in the pecking order and lays gorgeous, large green eggs. In a flock of very human-friendly chickens, she is the most suspicious and skittish. Nixie prefers the simple life of a chicken and doesn't get caught up in too many human things. She is a sweet girl who mostly keeps to herself but loves an exciting game of blueberry chase with her sisters. She keeps the flock of big personalities grounded with her calm, constant manner.

BUFFY

Buffy is our three-year-old Buff Orpington hen. She is fifth in the pecking order and lays small pink eggs. Though quite small for her breed, Buffy has a larger-than-life personality. As a chick, she captured the minds of thousands with her hilarious charisma, helping our Instagram account blow up. Intelligent and incredulous, she often gets into trouble and is the most likely hen to escape to the neighbor's yard. She also gets a little anxious sometimes, so she has an emotional support egg to sit on during hard times. Of note, she is the only hen in the flock who happily floats in water. This means she gets to go on paddleboard outings in the summer. Her nickname is "Buff-Buff."

JUNIPER

Juniper, our three-year-old Lavender Orpington hen, is sixth in the pecking order and lays tan eggs with purple speckles. Usually going by "Junie," she's the rockstar of the flock, with a significant fan base on social media. Whether biking, skiing, or just loafing, she is a force of nature in the chicken world. She's as large as a planet and as fluffy as a pillow. Junie is perhaps best known for her tendency to come inside at night and sleep in the house. Although she loves being outside with her sisters during the day, she much prefers the company of her mama hen inside at night. We often watch TV together in the evenings before going to sleep, sometimes joined by Buffy. Junie is also lovingly called "Juner."

JOSEPHINE

Josephine, our two-year-old Speckled Sussex hen, is also known affectionately as "Jojo." She is seventh in the pecking order and lays small tan eggs. She's an adventurous hen who will walk out any gate you leave open. She always wants to know what is beyond her view. Jojo is also a sweet and sensitive girl who enjoys spending time with her human and looks forward to getting massages on the couch. Most importantly, she's the fastest hen in the flock when it comes to chasing blueberries. Not only does Jojo win every blueberry race, she also taunts her sisters loudly by screaming for more blueberries.

MADRONA

Madrona, our two-year-old Buff Brahma hen, ranks eighth in the pecking order and lays small tan eggs. Although she appears to be a large, fierce bird, she is actually a gentle giant, second in size and weight only to Charlie. Sweet, curious, and fond of cuddling, Madrona enjoys galloping around the yard in search of treats—a beautiful sight to behold with her fully feathered legs and feet. She feels safest close to her mama hen and will follow her around the yard, even when she doesn't have treats. Her plumage is gorgeous and thick, which contributes to her nickname, "The Golden Polar Bear."

PENGUIN

Penguin! What is to be said of her? She was just the most special, magical little chicken soul to ever grace this planet. Penguin would be two years old now, but she died suddenly last summer, as chickens sometimes tragically do. She was a blue Ameraucana, ninth in the pecking order, and laid perfect little blue eggs. In life, we jokingly called her "The Wizard" because of how wise and odd she was. In death, she is now an actual wizard, watching over all of us. Of note, her beard was the most luscious, fluffy thing in the world. She is deeply, deeply missed, but her brief presence on this Earth was a gift for many. We love you, Peng!

NOVA

Nova is our two-year-old white Cochin hen who ranks ninth in the pecking order and lays dark tan eggs. She is a beautiful diva with perfectly white feathers that fully cover her legs and feet, giving her the appearance of wearing an all-white bell-bottom bodysuit, reminiscent of ABBA. Her temperament does not always fit her rockstar looks, as she is slightly timid and often broody. But she is growing into her fame. Nova is an incredible snuggler and has captured the hearts of many with her showstopping looks. As one of the calmest chickens in the flock, she regularly makes appearances in mama hen's Zoom classes for nursing school.

ABOUT THE AUTHOR
AND ILLUSTRATOR

Tedra Hamel lives in Washington state with her backyard flock. She is a dedicated outdoor enthusiast and a loving chicken keeper. Her art has always featured her real-life hens. She is deeply inspired by both nature and hens, and her work is a love letter to the sweeping beauty of the natural world as well as the sweet and curious disposition of the backyard chicken. She accidentally became an artist when her flock's Instagram, @therapy_chickens, got famous. Her other life path is as a critical care nurse and outdoor guide.

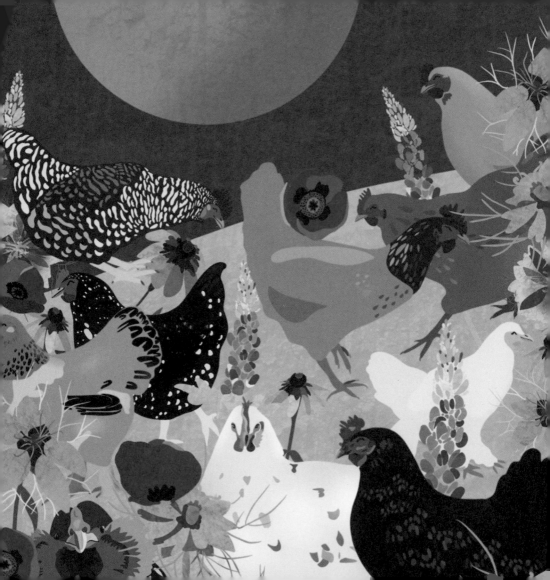

AUTHOR'S NOTE

Dear readers,

Thank you kindly for your care, enthusiasm, and connection. This project has always been very near and dear to my heart. It became ever so much more when we suffered a string of losses during the year of writing this book.

Our dear Charlie died of an unknown illness in late spring 2023. She was adventurous, cuddly, and brave until the very end. Then, later that summer, we had a terrible accident. A dog broke into our coop, and only Nixie survived.

We had an outpouring of grief from our friends and followers. While the absence of the flock is heart wrenching, it brings me enormous joy to know that their legacy will live on in this book and in the hearts of people around the world.

Under Nixie's vigilant care, we are now growing a new little flock as the next generation of therapy chickens. The gentle spirits of Bella, Lulu, Charlie, Buffy, Juniper, Josephine, Madrona, Penguin, and Nova will go on and on. It is in their beautiful memory that I dedicate this book.

First published in 2024 by Wellfleet Press,
an imprint of The Quarto Group,
142 West 36th Street, 4th Floor,
New York, NY 10018, USA
T (212) 779-4972 F (212) 779-6058
www.Quarto.com

Wellfleet Press titles are also available at discount
for retail, wholesale, promotional, and bulk purchase.
For details, contact the Special Sales Manager by
email at specialsales@quarto.com or by mail at The
Quarto Group, Attn: Special Sales Manager, 100
Cummings Center Suite 265D, Beverly, MA 01915 USA.

10 9 8 7 6 5 4 3 2 1

ISBN: 978-1-57715-403-7

Digital edition published in 2024
eISBN: 978-0-7603-8718-4

Library of Congress Cataloging-in-Publication Data

Names: Hamel, Tedra, author.
Title: Therapy chickens : let the wisdom of the flock
 bring you joy / Tedra
 Hamel.
Description: New York : Wellfleet Press, [2024] |
 Summary: "Learn to be a
 little happier every day with Tedra Hamel's adorable
 and silly flock of
 hens in Therapy Chickens"– Provided by publisher.
Identifiers: LCCN 2023032343 (print) | LCCN
 2023032344 (ebook) | ISBN
 9781577154037 (hardcover) | ISBN 9780760387184
 (ebook)
Subjects: LCSH: Self-confidence. | Emotions in
 children. | Happines. |
 Chickens–Social aspects.
Classification: LCC BF575.S39 H36 2024 (print) | LCC
 BF575.S39 (ebook) |
 DDC 155.4/124–dc23/eng/20230807
LC record available at https://lccn.loc.
 gov/2023032343
LC ebook record available at https://lccn.loc.
 gov/2023032344

Group Publisher: Rage Kindelsperger
Creative Director: Laura Drew
Art Director: Beth Middleworth
Managing Editor: Cara Donaldson
Editor: Elizabeth You
Cover Design: Beth Middleworth
Interior Design: Laura Klynstra

Printed in China

This book provides general information on various widely known and widely accepted images that tend to evoke
feelings of strength and confidence. However, it should not be relied upon as recommending or promoting any
specific diagnosis or method of treatment for a particular condition, and it is not intended as a substitute for
medical advice or for direct diagnosis and treatment of a medical condition by a qualified physician. Readers who
have questions about a particular condition, possible treatments for that condition, or possible reactions from the
condition or its treatment should consult a physician or other qualified healthcare professional.